Skira**M**ini**ART**books

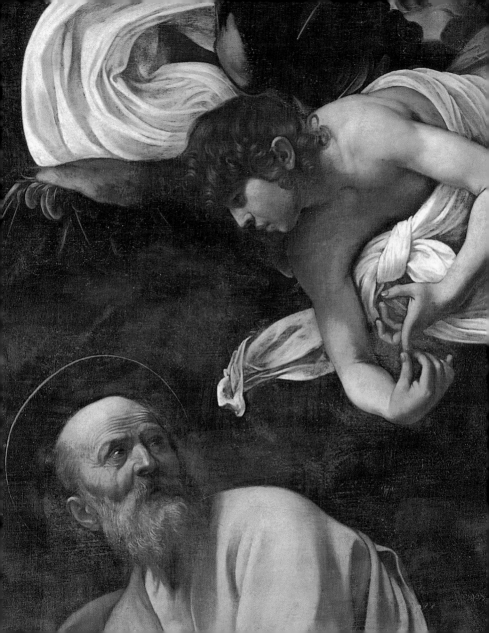

Francesca Marini

CARAVAGGIO

SKIRA

Skira editore
SkiraMiniARTbooks

Editor
Eileen Romano

Design
Marcello Francone

Editorial Coordination
Giovanna Rocchi

Layout
Anna Cattaneo

Editing
Maria Conconi

Iconographical Research
Marta Tosi

Translation
Susan Ann White for Scriptum,
Rome

First published in Italy in 2009
by Skira Editore S.p.A.
Palazzo Casati Stampa
via Torino 61
20123 Milano
Italy

www.skira.net

Printed and bound in Italy.
First edition

ISBN 978-88-572-0273-0

Front cover
The Calling of St. Matthew
(detail), 1599–1600
San Luigi dei Francesi, Contarelli
Chapel, Rome

Facing title page
St. Matthew and the Angel
(detail), 1602
San Luigi dei Francesi, Contarelli
Chapel, Rome

On page 86
Beheading of St. John the Baptist
(detail), 1608
Oratorio di San Giovanni Battista
dei Cavalieri, La Valletta (Malta)

Contents

Caravaggio

Michelangelo Merisi, called Caravaggio, was born in Milan in 1571. He was the son of Lucia Aratori and Fermo Merisi, the architect, overseer and household administrator of Francesco Sforza, and member of a cadet branch of the powerful Milanese dynasty and Marquis of Caravaggio, a town located a few kilometres from Milan, from which the artist took the name by which he is now known. Since Michelangelo was apprenticed at an early age to the painter Simone Peterzano, it is likely that he displayed artistic gifts during his childhood that was spent at the court of the cultured Marchioness Costanza Colonna Sforza, the daughter of Marcantonio Colonna, admiral of the papal fleet and head of one of the oldest and most powerful noble families in Rome.

During the period before his departure to Rome in 1592, Caravaggio had the opportunity to peruse the precepts of Leonardesque painting in *The Last Supper* by the master in Milan. He also probably undertook the journey to Venice that Bellori tells us was made as a result of his delinquent behaviour, and perhaps went to Mantua, where major perspectival and expressive innovations had been introduced by Giulio Romano, whose powerful illusionism had become an undisputed model for Lombard painters. Prior to 1592, Caravaggio would have studied with particular attention the natural world and the reality of everyday life as depicted by a group of painters, namely Moretto, Savoldo and Moroni, who were active in Milan, Bergamo, Brescia and Cremona, throughout the sixteenth century.

When Caravaggio arrived in Rome, he exploited his connections with the Marquis and Marchioness Sforza and the Colonna family. The only information we have about the first years he spent in the city, between 1592 and 1593, is that supplied by his biographers. They

tell us that, at twenty-one, Caravaggio worked for an obscure Sicilian painter named Lorenzo, then for Antiveduto Gramatica for whom he painted "half-length figures", and lastly in the flourishing workshop of Giuseppe Cesari, also known as Cavalier d'Arpino. Giuseppe Cesari was the most highly-rated painter in Rome, a personal friend of the new pope Clement VIII and "beloved of princes and illustrious personages". In Cesari's *bottega*, Caravaggio "was given flowers and fruit to paint". The still life was a genre in itself that was considered minor in the hierarchy of subjects imposed by theorists. Nonetheless, Caravaggio's main aim was to represent "truth" regardless of any theoretical hierarchy of genres. Thus, for him the still-life elements of a work were as important as the figures, with which they were perfectly integrated through his use of a unifying light source. The principle of "faithfulness to truth" was so fundamental to the artist's work that it enables us to recognize in his painted figures the characters who accompanied him during the various stages of his life, whom he used as models both in compositions for private collectors, which allowed him a certain freedom, and in his religious works destined for a wider public. Over the years, this practice caused not a few problems for Caravaggio: more than once he used fellow travellers or apprentices, like Mario Minniti or the young Francesco Boneri, but also famous courtesans of the period such as Fillide Melandroni and Maddalena Antognetti, who might have been acceptable had they been depicted as pagan goddesses, but when represented as the Madonna resulted in the work being rejected out of hand by the Catholic client.

The Martyrdom of St. Matthew (detail), 1600–01
San Luigi dei Francesi, Contarelli Chapel, Rome

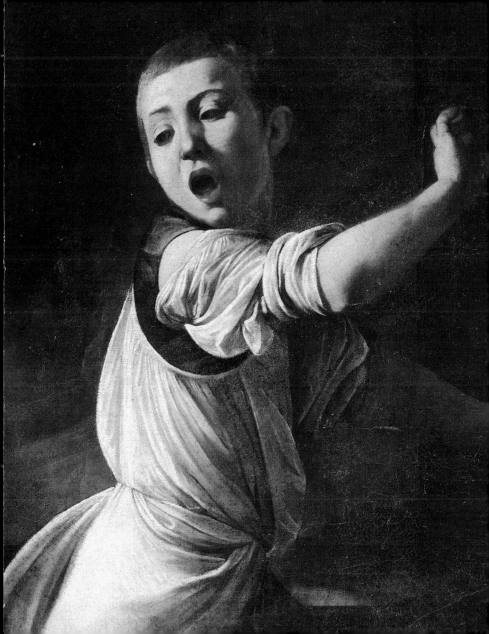

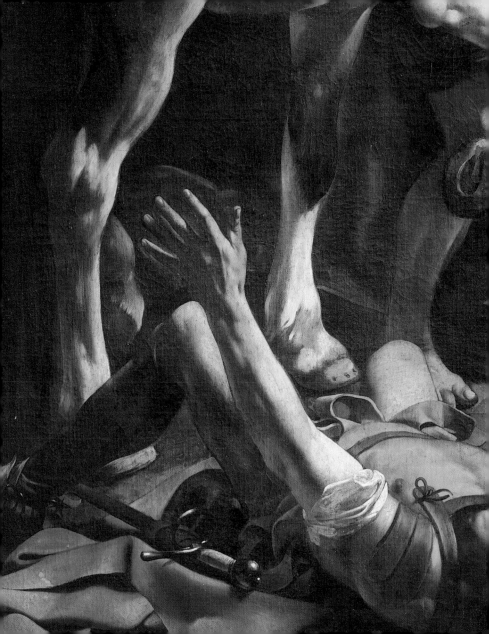

In January 1594 Caravaggio decided to "stand on his own two feet" and left Cavalier d'Arpino's workshop. Unfortunately, he was not able to sell his paintings and "was penniless and very badly dressed, so some gentlemen of the same profession [offered him] charity, bringing him relief". He dragged out his life in the Rome art underworld with his friend Mario Minniti, and in *The Fortune Teller* and *The Cardsharps*, he elevated the representation of that world to what was then considered the highest moral and intellectual level of painting, namely the "history" genre in which the representation of noble historical or religious actions evoked examples of virtue and beauty. It was precisely these two paintings in which street life was depicted and interpreted in a way that was completely "true" that opened the doors of the Rome aristocracy's *palazzi* for Caravaggio, lifting him out of the poverty that had forced him to sell for only eight scudi what would later become one of his most acclaimed paintings. The description of *The Fortune Teller* provided by the biographer Giulio Mancini enables us to understand that, rather than the subject itself – a gipsy pretending to read the hand of a cavalier while sliding a ring off his finger – it was the authenticity of the gipsy's and the young gallant's expressions that struck the contemporary imagination.

The Conversion of St. Paul (detail), 1600–01 Santa Maria del Popolo, Cerasi Chapel, Rome

It may have been one of the many dealers of ill repute frequented by Caravaggio in this period who introduced him to the aristocratic Cardinal Del Monte. Francesco Maria Borbone Del Monte was one of the key figures in the intellectual and political life of this period, and, once he had become familiar with Caravaggio's work, he invited the young painter to live at his residence, Palazzo Madama. Car-

avaggio's entering the cardinal's retinue meant a complete change of environment, and led him to explore completely new subjects. Music and musical instruments became part of his repertoire, and in *The Musicians* – where the lute, horn, violin and even the sheet music depicted came from the cardinal's collection – Caravaggio interpreted these iconographic novelties within the framework of complex allegories ennobled by references to antiquity. Hence the elegant modern dress of *The Fortune Teller* and *The Cardsharps* is replaced in this painting by soft drapery clearly of classical inspiration. The relationship between music and science at the court of Cardinal Del Monte at the turn of the century, were not casual. In keeping with a trend that was shortly to lead, via the recitative, to the birth of opera, the noble cardinal who protected Caravaggio firmly upheld musical theories that advocated a return to "simple and natural" music for solo voice and instrument, whose sole aim was to move the soul, unlike archaic Flemish contrapuntal polyphonies.

The *Dialogue on Ancient and Modern* Music, which dealt with the transition from ancient to modern, was written by Vincenzo Galilei, the father of Galileo, the first modern scientist. Galileo was often a guest at the cardinal's residence while Caravaggio was staying there, and in all probability they met. Cardinal Del Monte's brother, Guidobaldo, was an excellent mathematician and physicist, as well as the author of the first systematic treatise on mechanics, and the two Del Monte brothers supported the scientist at the beginning of his career and defended him at the trial brought against him by the Inquisition.

In order to facilitate his researches, Cardinal Del Monte decided to set up an alchemical distillery in the country villa he bought at Porta Pinciana in 1596. It was on the ceiling of this distillery, known

at the time as the Casino, that Caravaggio executed his only work on masonry. Caravaggio painted the ceiling not a fresco but with oils, like he did his canvases, and defied his detractors by depicting the symbols of an alchemical triad based on the one invented by Paracelsus. Jupiter represented sulphur and air, Neptune mercury and water, Pluto salt and earth, and the figures were represented from below in dizzying perspective. The Casino ceiling was rich in virtuoso techniques founded on unanimously accepted principles, but this was not enough to silence the artist's denigrators who refused to approve of a paint-

ing that was not primarily based on drawing. Not only was Caravaggio considered uncouth, he was largely accused of "knowing nothing about planes or perspective" and of having developed, precisely for this reason, the technique of composing scenes with more than one figure by transposing the models, painted from life, onto the canvas one by one, starting from the most distant figure and ending with the one in the foreground.

The manner in which Caravaggio executed his works aroused, and still arouses, considerable discussion about his technique that did away with preliminary drawings. His completely true depiction of reality was achieved by posing each of the models separately and then assembling them on the canvas. This enabled him to create compositions in which the short incisions in the ground that have recently been revealed beneath the layer of oil paint by infrared reflectography examinations, were very likely the only points of reference he used to position the elements of the picture.

In the broader context of representation from life, between 1595 and 1596 Caravaggio's researches explored the transposition

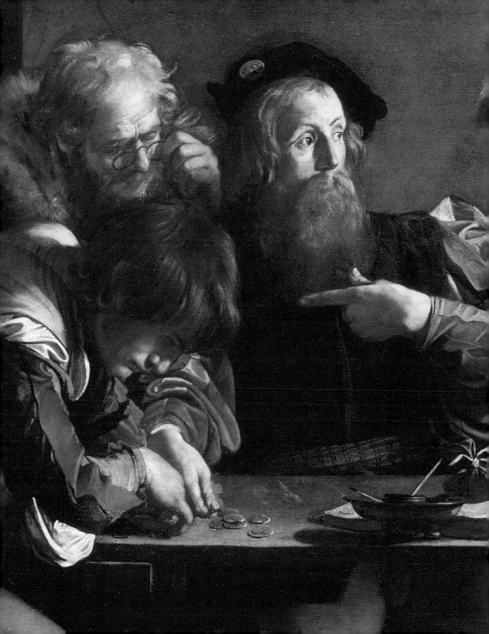

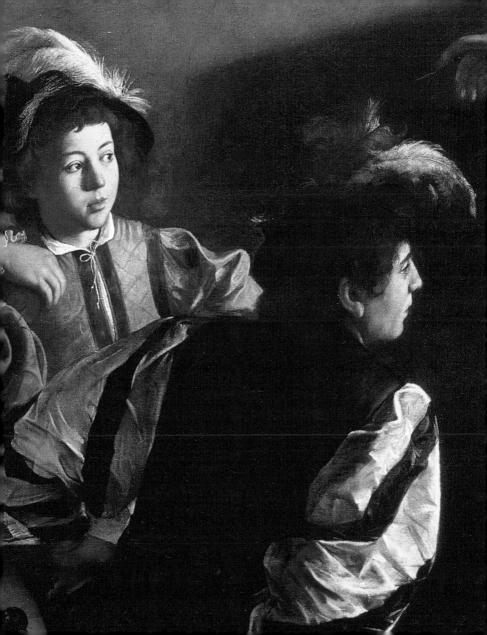

on canvas of what at the time were called the "motions of the soul", which were reflected in the changes in expression provoked by extreme feelings of joy, anger, pain or fear. The painting of a *Boy Bitten by a Lizard*, of which there are two known versions – which is not unusual since the artist executed copies of other works – is a self-portrait depicting the sudden reaction to being bitten by the reptile. His expression seems frozen, a mixture of pain and anger, and we cannot but see a resemblance to the sketches of faces caught in moments of surprise, pain or laughter that Leonardo had executed as part of his studies on the true representation of the natural world and on the motions of the soul.

These experiments with representing exaggerated expressions, which were to have considerable influence on his entire œuvre, also originated in the startlingly real *Head of the Medusa*, whose frozen scream of horror is accentuated by the writhing serpents and spurting blood, which Caravaggio painted on a shield for Del Monte, as a gift for Ferdinando I de' Medici, Grand Duke of Tuscany.

Caravaggio sifted through Leonardo's researches several times; however, the Medusa's oblique gaze, dilated pupils and mouth frozen in a scream were also inspired by the grotesque expressions of classical masks, making the work part of a great tradition, not only due to the subject – the Medusa from ancient Greek mythology – but also to its treatment. The same kind of immediacy is captured in *Judith Beheading Holofernes*, executed *circa* 1599, where Caravaggio chooses to depict the actual moment when Judith beheads the tyrant Holofernes, ignoring all the more illustrious precedents.

In 1599, Caravaggio obtained the commission for the decoration of a chapel in the church of San Luigi dei Francesi. Mathieu Cointrel, the Frenchman who had become Cardinal Contarelli and had purchased the chapel in 1565, had been dead for some time, and the executor of his will, Virgilio Crescenzi, had entrusted the pictorial decoration to Cavalier d'Arpino in 1591. The latter painted the frescoes on the ceiling but, weighed down by papal commissions, did not execute the other decorative elements that the cardinal had specifically requested before his demise.

Rather than using the wall surface to depict *The Vocation of St. Matthew* and *The Martyrdom* of the saint, in accordance with Cardinal Contarelli's detailed request, Caravaggio executed them on two huge canvases. A support of this size fitted to the wall of a chapel was already something completely new in a Rome church, let alone Caravaggio's interpretation of the two subjects. *The Calling of St. Matthew* represents a scene from everyday life, whose atmosphere completely devoid of rhetoric is created by the beam of bright light that accompanies Christ's gesture, linking him to Matthew in a moment which is suspended by that single movement. After repeated compositional *pentimenti*, all of which are evident beneath the pictorial layer, *The Martyrdom of St. Matthew* developed concentrically around the figure of the executioner in the act of striking the future martyr.

Not everything went smoothly on this commission. When the first version of the altarpiece with *St. Matthew and the Angel* – executed after the two paintings for the side walls – was hung in the chapel, it was held to be too "strong" by the French congregation who could not tolerate two – perfectly foreshortened – feet sticking out towards the faithful in the foreground, which belonged to an illiter-

ate saint who had to be helped by the angel. Caravaggio had to substitute the canvas with a new version that was more acceptable to the tastes of the confraternity brethren. But he was famous now, his success was firmly established and his pictorial language was fully mature in the monumental and dramatic sense.

Everything was held together by light in the Contarelli paintings: a light symbolizing the divine, which Caravaggio was able to create by studying Leonardo's concepts of the representation and perception of reality, as interpreted by the Lombard painter and theorist Gian Paolo Lomazzo. The dialectic between light and shade that had already led Caravaggio "to intensify the dark shades" had developed to the full, becoming formally indispensable to the representation of the natural he had so relentlessly sought to achieve.

St. Catherine of Alexandria
(detail), 1597
Museo Thyssen-
Bornemisza, Madrid

Caravaggio had become so famous that when the next contract for the decoration of a chapel was stipulated, in September 1600, he was offered a fee of four hundred scudi. The client was Tiberio Cerasi, a friend of Vincenzo Giustiniani, who was so wealthy he was able to buy himself the office of Treasurer of the Apostolic Chamber and of Clement VIII.

Cerasi had just purchased a chapel in the church of Santa Maria del Popolo in Rome, and he wanted two works depicting *The Conversion of St. Paul* and *The Martyrdom of St. Peter* for the side walls, and an *Assumption of the Virgin* for the altar. Tiberio Cerasi split the commission for the chapel works, hiring Caravaggio to do the lateral paintings and engaging Annibale Carracci – the other star of the

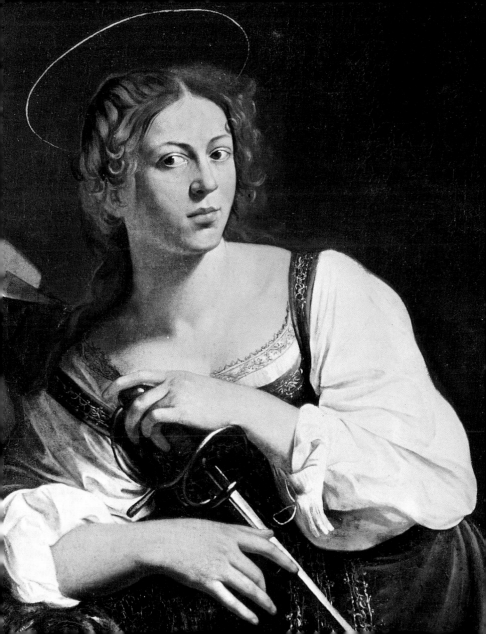

Rome artistic firmament at the beginning of the seventeenth century whose work would be seen as the complete opposite of Caravaggio's true-to-life style – to execute the altarpiece. The *Assumption* presented by Carracci was accepted on the spot, while the first version of *The Conversion of St. Paul* was rejected. Perhaps the client thought the scene was too "busy", the fact remains that Caravaggio reinterpreted the subject, producing a version dominated by the absolute calm of the two human figures, the horse and the divine light. The same still, suspended atmosphere was created for *The Martyrdom of St. Peter*, and also in this case it was the second version that was finally accepted.

These were not the only rebuffs that Caravaggio had to stomach: the *Death of the Virgin*, executed for the Cherubini Chapel in Santa Maria della Scala a few years after the Cerasi canvases, and now in the Louvre, was also turned down. The rectors of the church found such a contemporary mourning scene inconceivable, nor could they accept the Holy Virgin being depicted as a woman of the populace in turn-of-the-century Rome. Was this really why they rejected the painting or, as Caravaggio's biographers suggest, did the Carmelite brothers have the largest work he had ever painted in Rome taken down because he had "depicted Our Lady as a courtesan loved by him" or because "he had so disrespectfully made the Madonna swollen up and with bare legs"?

Caravaggio had just started work on the second versions of the canvases for Tiberio Cerasi in June 1601, when he signed a contract for a new commission, in which he is described as "residing in the palazzo of […] Cardinal Mattei". It is not clear if he had actually moved there, though we know that between the spring of 1601 and the year

1603, the artist executed several works for Ciriaco Mattei, including the *Supper at Emmaus* in London, the *St. John the Baptist – Youth with a Ram* in the Pinacoteca Capitolina in Rome and the version of *The Taking of Christ*, recently identified as the one in Dublin, for which he was paid a hundred and twenty scudi.

At the same time he continued to produce works for his other loyal protector, Vincenzo Giustiniani, also fitting in some public commissions. It is likely, in fact, that precisely in 1602, or thereabouts, Caravaggio began the only public work that met with his detractors' approval: the *Deposition* now in the Pinacoteca Vaticana. This painting was commissioned from Caravaggio by Gerolamo Vittrici, possibly to respect the wishes of his Uncle Piero, the Pope's dresser, who had died in 1600. The altarpiece was to grace the family chapel in Rome's new church of Santa Maria in Vallicella, and in fact it is recorded as hanging there in September 1604. Possibly to avoid another rejection but without being any less faithful to "truth", Caravaggio interpreted the subject in a monumental key while making visible references to "lofty" models: classical sculpture and Raphael's painting.

I n a period marked by complex philosophical debates on the legitimacy of certain images, on genre hierarchies and on the role of drawing in painting, which mainly took place in academic circles, Caravaggio said that "a worthy painter [is one] who knows how to paint well and imitate natural things well". However, his contemporaries did not only have a problem with several of his works being in churches or being owned by a well-established circle of collectors, they also did not like the fact that, as Bellori tells us, "the painters then in Rome were greatly impressed by his novelty and the younger ones

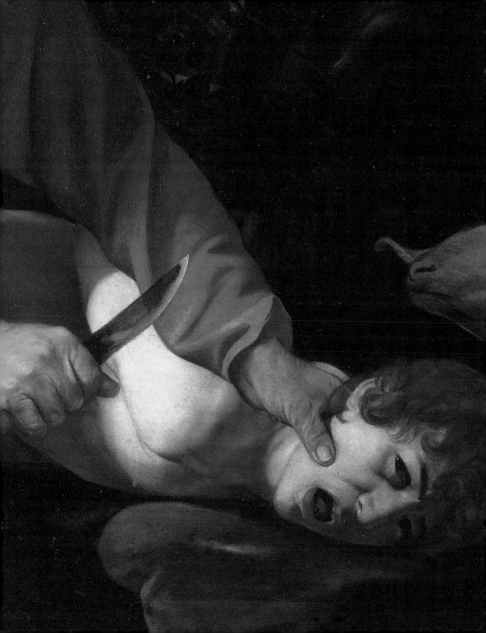

especially gathered round him and praised him as the only true imitator of nature. Looking upon his works as miracles, they outdid each other in following his method". Caravaggio was overturning the system and, almost to his regret, found himself with an ever-larger number of imitators and followers.

A dispatch from the Duke of Modena's ambassador tells us that Prince Marcantonio Doria was so taken with Caravaggio's painting that he actually offered him six thousand scudi to paint the loggia of one of his residences. The prince had established a close relationship with the artist and his extraordinary offer was designed to keep him in Genoa. Caravaggio refused it, but found himself in dire straits when he returned to Rome in 1606. The few possessions he owned had been seized because, according to the landlady from whom he had rented a house in Vico San Biagio, he had not paid the rent for at least six months. All the money he had earned must have dwindled away, otherwise it is difficult to imagine why, in October 1606, he accepted a fee of only seventy-five scudi for an altarpiece to be hung in St. Peter's, the most important basilica in Rome. It is true that having one of his works in such a prestigious place would have restored his honour and his fame, but the fact that he agreed to such a low figure when the going price for an altarpiece was at least two hundred scudi, corroborates the documentary sources of the period that describe the artist as being in desperate need of money.

Sacrifice of Isaac
(detail), 1603–04
Galleria degli Uffizi,
Florence

During the final work on St. Peter's in Rome, which had then been open for at least a century, the Chapel of the Palafrenieri (papal grooms) was moved and required a new altarpiece. Caravaggio

was chosen to execute this work which was to depict St. Anne, the patron saint of the grooms and the mother of Mary. As agreed with the clients, Caravaggio depicted Mary and the Christ Child in the act of crushing the serpent associated with the original sin, in the presence of St. Anne. The painter imbued the scene with the familial intimacy found in some 16th-century Lombard altarpieces, yet even this painting was taken down, and sold to Scipione Borghese. Like Vincenzo Giustiniani, the Mattei brothers and Del Monte, Scipione had been a great admirer of Caravaggio's work for some time, and the painter executed for him the *St. Jerome* now in the Galleria Borghese, Rome. Scipione Borghese was cardinal-nephew to the new Pope Paul V who had been elected in May 1605. During the celebrations of the first anniversary of his coronation, "In Campo Marzio […] Michel Angelo Caravagio, painter, wounded and killed Ranuccio from Terni with a thrust to the inside of his thigh, from which he died after barely having time to confess". Ranuccio Tomassoni was from an influential military family with Spanish sympathies who had recently aligned with the politics of the new Pope, and his murder, even if it had been accidental, could not be ignored. Consequently, Michelangelo Merisi was forced to flee Rome in order to escape arrest, and he sought help from the Colonnas. The family owned property to the south-east of Rome, in Zagarolo, Palestrina and Paliano, where Caravaggio spent four months, moving from one estate to another while awaiting sentence. When he was condemned to death, he had to leave the papal state for good, taking refuge in the palazzo of Don Marzio Colonna, Prince of Zagarolo, in Naples.

Through his new protector, Caravaggio obtained commissions that kept him busy throughout the winter of 1606 and for the first few

months of 1607. These included the painting he executed for the Pio Monte della Misericordia Congregation, which was certainly his most prestigious public work. The group of young Neapolitan noblemen who had founded the congregation wanted a large altarpiece depicting the seven works of mercy: the six nominated by Christ in the Gospel of St. Matthew plus the burial of the dead – which following the recent famine had become a major problem for the city. In a very short time Caravaggio produced a painting representing the seven works, in which he created an animated, complex theatre machine inspired by street life. Indeed, his *Seven Works of Mercy* revolutionized the entire panorama of southern Italian painting, becoming a primary pictorial reference for all the artists who were then undergoing training. This major painting was followed by other commissions, such as the *Madonna of the Rosary* for the Carafa Colonna family and the *Crucifixion of St. Andrew* for the viceroy of Naples.

To avoid the death penalty, Caravaggio seized an opportunity that was again provided by the Colonna family. Fabrizio Colonna, the second son of the marchioness Costanza, was more or less the same age as the painter and, like him, had been accused of serious crimes. Nonetheless, in 1606 Fabrizio had been made commander of the fleet of the Order of the Knights of Malta. For about seventy-five years Malta had been the headquarters of the religious order formerly known as the Knights of St. John of Jerusalem, which welcomed the most unruly aristocratic scapegraces, endowing them with a kind of immunity in return. Therefore, it seems likely that Caravaggio, still protected by the Colonna family, was able to enter the order that was his only means of salvation. After a first brief visit to

25

Malta in 1607, he returned in the spring of the following year and began the portrait of the Grand Master of the Knights of Malta, Alof de Wignacourt, now in the Louvre. It appears that de Wignacourt did everything to support and accommodate the artist, immediately granting him all the privileges enjoyed by young aspirant knights and exonerating him from the usual tests and the service at sea that was normally required, thus leaving him free to devote himself to painting. Caravaggio was made a knight of the order on 14 July 1608 and in the document of admittance it was specified that the office had been granted on merit and not birth, thus making it evident that had he been a less talented painter he would never have been accepted. Meanwhile, Caravaggio had already begun the only large altarpiece that bears his signature written in the blood gushing from St. John the Baptist's severed head. We do not know for certain whether Fabrizio Sforza Colonna commissioned the painting for the order's new oratory; in any event, the monumental *Beheading of St. John the Baptist* brought Caravaggio, "as well as the honour of the cross, [...] a sumptuous gold necklace, [the] gift of two slaves and other demonstrations of respect and satisfaction with his work".

In October of that year, however, Michelangelo was under arrest again, this time in the *guva* at Fort Sant'Angelo in Malta. The *guva* was a pit just over three metres deep, dug out of the rock. None of the documents of the Order of the Knights of Malta and none of the chronicles of the period clarify the reason for his having been imprisoned anew. The only clue is to be found in the document regarding his expulsion from the order, which describes him as "putridum et foetidum". His detention is not the only thing shrouded in mystery: we also do not know how Caravaggio was able to escape from

the *guva* before the week was out and to find a boat that took him to Syracuse in Sicily, without the help of influential friends.

After escaping from Malta, the painter was constantly on the run: Syracuse, Palermo, Messina, then back to Naples, always desperately searching for a new way out. When he landed in Syracuse after fleeing Malta, he found an old friend from his early days in Rome waiting for him: Mario Minniti, who had since established himself as a painter locally. However, the fact that the Syracuse Senate immediately commissioned him to paint an important altarpiece depicting St. Lucy, the patron saint of the city, for the church dedicated to her, is also something of a mystery, since Caravaggio was a fugitive at the time.

As soon as he arrived in Messina he was asked to paint another important work for which he was paid the exorbitant sum of one thousand scudi. The painting was for a Genoese merchant by the name of Lazzari who resided in the city, and who gladly accepted Caravaggio's suggestion of depicting the *Raising of Lazarus* – given the similarity between the names – for the altar of the chapel that the merchant had recently bought.

At the very moment that Caravaggio's fame was undisputed, following the death of Annibale Carracci – the only painter who was held to be of equal importance but who belonged to a school that was light years away from that of Merisi – the artist again changed his pictorial language while he continued to move back and forth across Italy to escape capture.

In Naples Caravaggio found himself within the protective circle of the Colonnas once more. He lived at the house of Luigi Chiaia

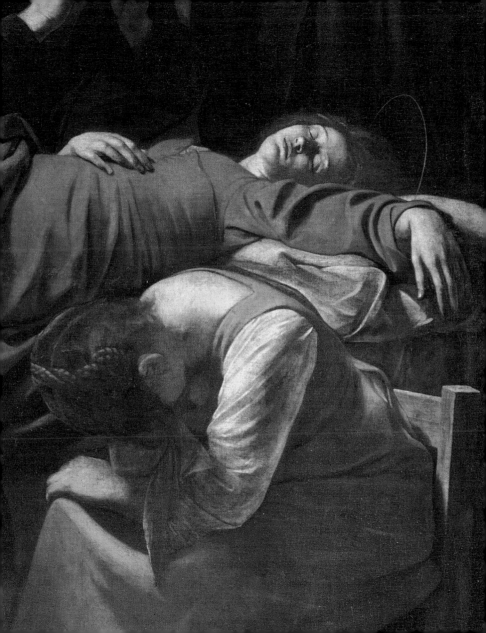

Colonna where he probably painted at least five of the works known to have been executed in this period, namely *Salome with the Head of John the Baptist*, *The Denial of St. Peter*, the two versions of *St. John the Baptist* and the *Martyrdom of St. Ursula*. These paintings marked a new stage in Caravaggio's art, which was characterized by a more essential style and rapid execution, and figures on a smaller scale. These elements were congenial to the use of a reddish ground as the basic colour and to the figures emerging from "fierce backgrounds and shadows" with streaks of light. The relationship between the figures and the spaces was completely new: scenes with several figures were framed by large, bare spaces whose architecture was sketchily indicated with slight variations in the darker shades.

Finally, the dense and powerful network of supporters that had accompanied him through the last two decades and had promoted his request for a papal pardon had achieved its much hoped for goal. After four years of exile, Pope Paul V pardoned the most renowned painter of the day. But it was too late. One of the official dispatches sent from Rome in 1610 announced that: "The celebrated painter Michiel Angelo da Caravaggio died at Porto Ercole while travelling from Naples to Rome to receive His Holiness's pardon from the death sentence he had received".

As the papal nuncio Deodato Gentile explained, while informing the Apostolic Secretary Scipione Borghese about Caravaggio's death, the felluca with his possessions, including the paintings he was bringing as a gift for the Pope, had gone back to Naples. The paintings, at least, reached Costanza Sforza Colonna, but the painter's body was not found, despite lengthy searches.

Caravaggio had achieved celebrity in the space of a few years, at the beginning of the seventeenth century. He had become the idol of young artists who adopted not only his painting style but also his lifestyle and mode of dress. The master's technique was imitated by painters who did not understand its true essence and emulated the "manner" of Caravaggio just to reproduce his model. His fame was so cataclysmic that even painters who were no longer young at the beginning of the seventeenth century, like Giovanni Baglione, felt the need to follow the road that he had opened up at the close of the sixteenth century, introducing the modern age.

Works

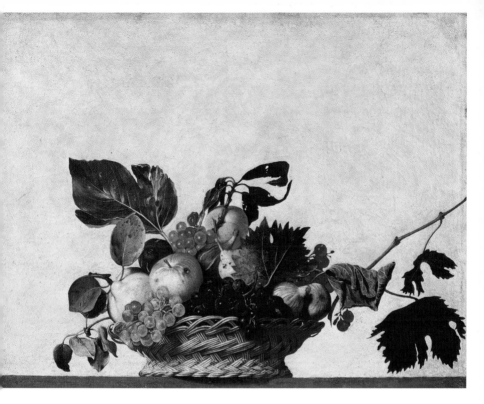

1. *Basket of Fruit*, 1597–98

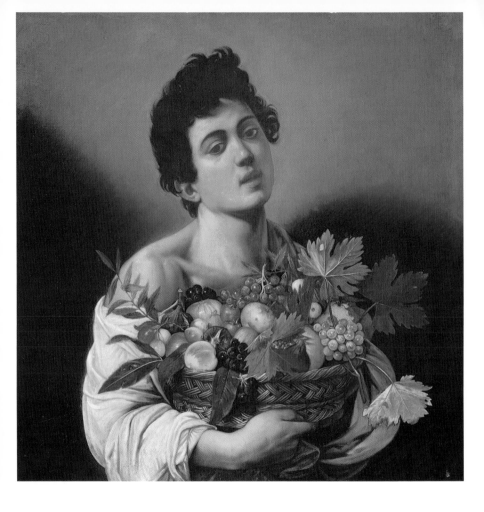

2. *Boy with a Basket of Fruit*, 1593–94

3. *Sick Bacchus*, 1593–94

34

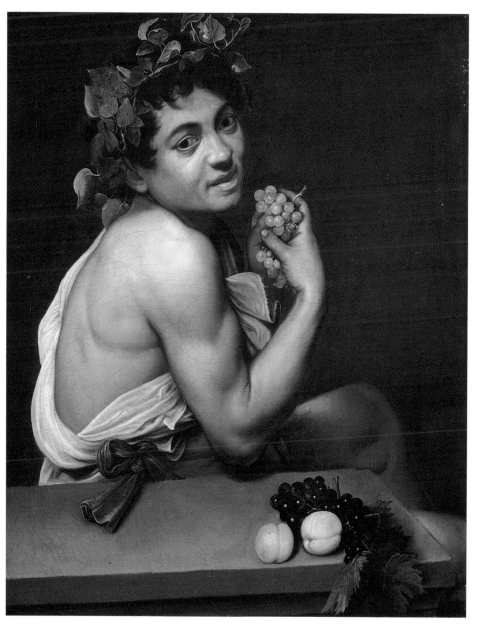

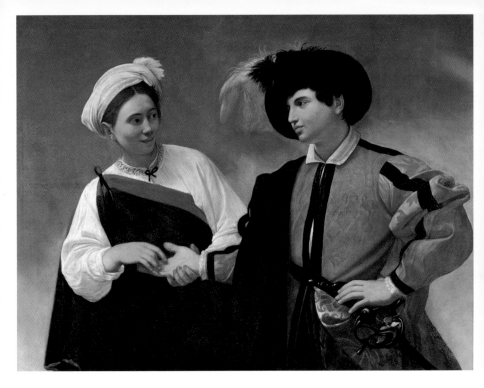

36

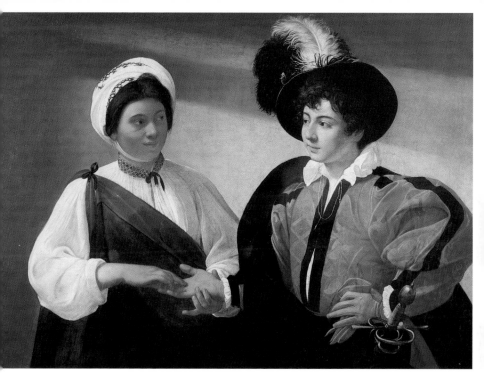

4. *The Fortune Teller*,
1593–94

5. *The Fortune Teller*,
1596–97

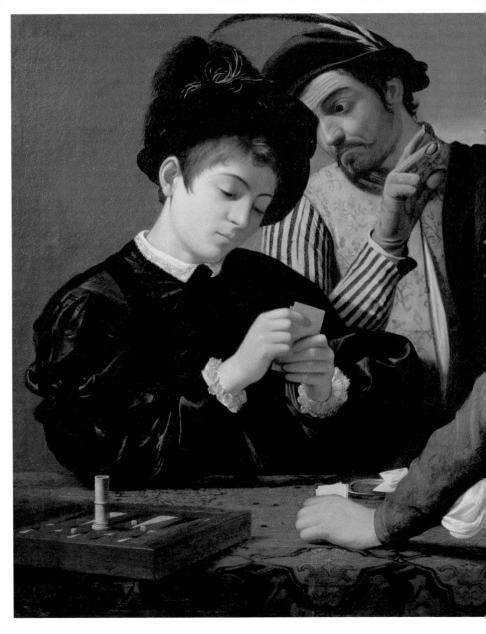

6. *The Cardsharps*, 1594

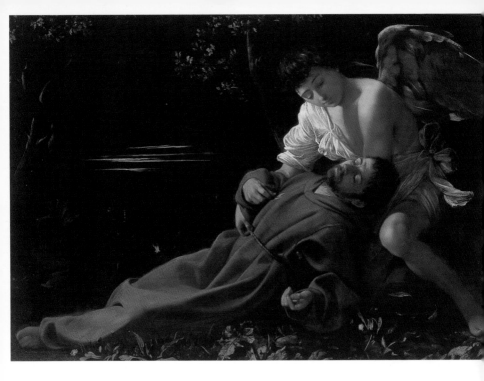

7. *St. Francis of Assisi in Ecstasy*, 1594–95

8. *Rest on the Flight into Egypt*, 1595–96

40

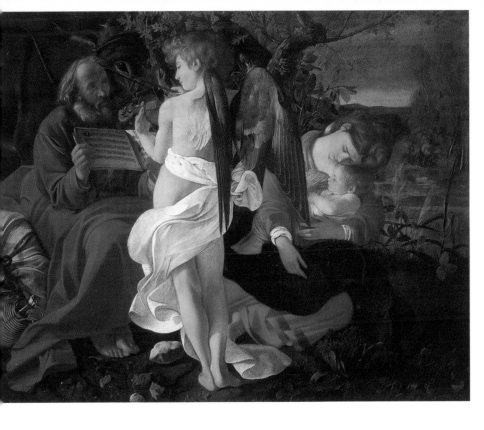

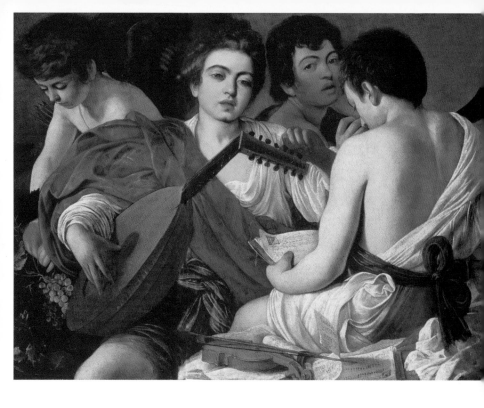

9. *The Musicians*, 1595

10. *The Lute Player*,
1595–96

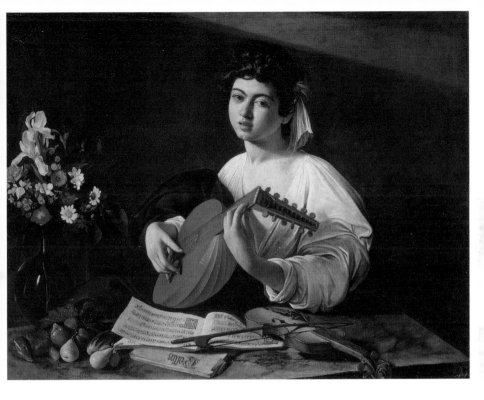

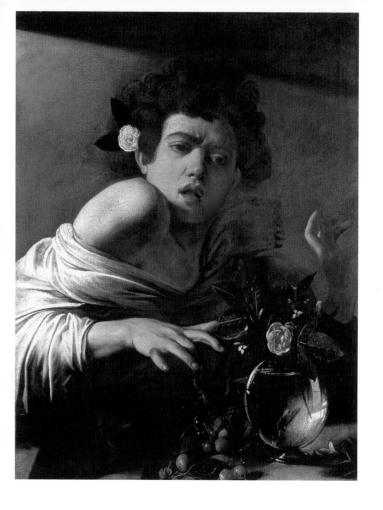

11. *Boy Bitten by a Lizard*, 1595–96

12. *Bacchus*, 1596–97

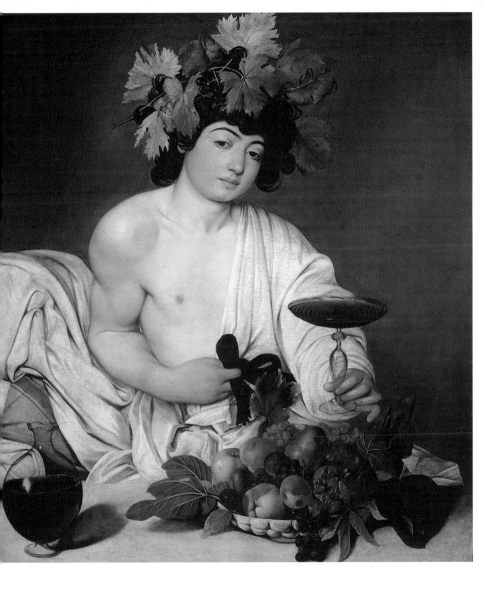

45

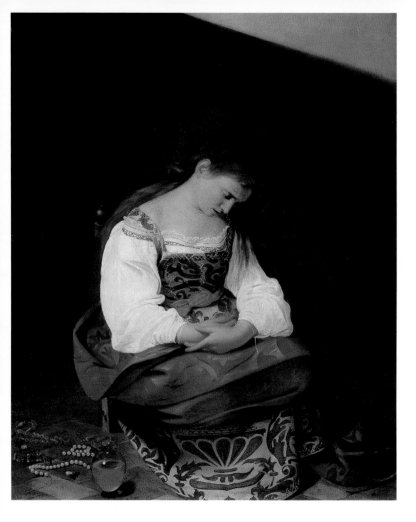

13. *Penitent Magdalene*,
1594–95

14. *St. Catherine
of Alexandria*, 1597

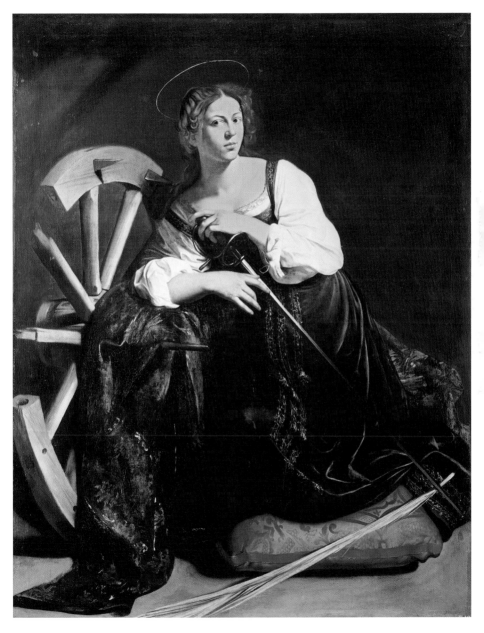

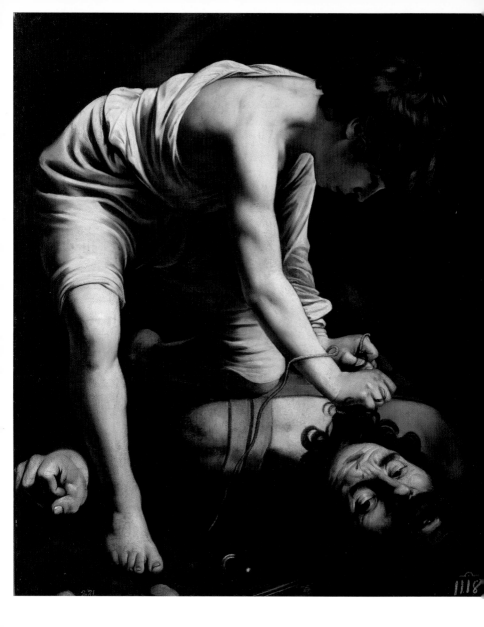

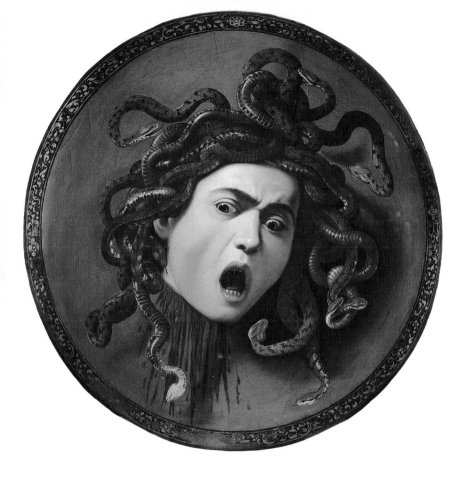

15. *David and Goliath*,
1597–98

16. *Head of the Medusa*,
1598

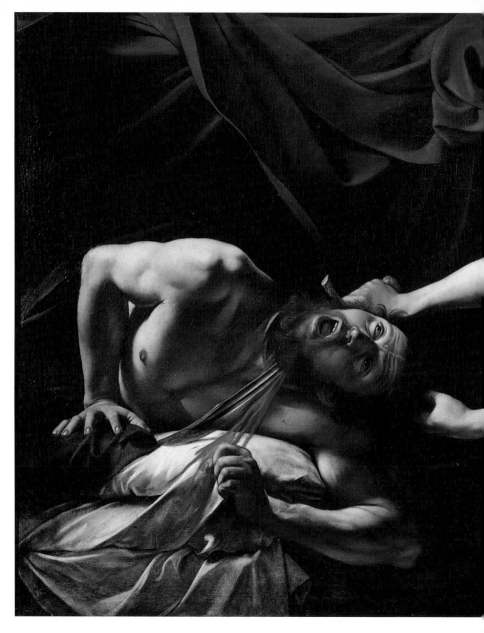

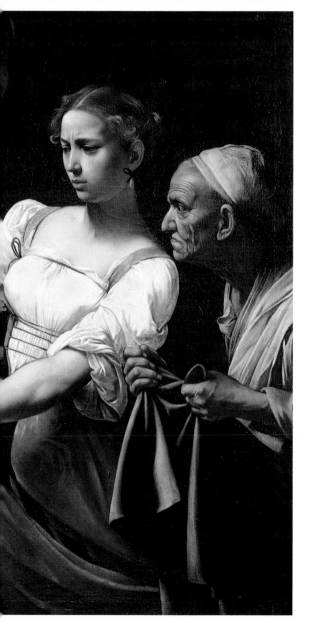

17. *Judith Beheading Holofernes*, 1599

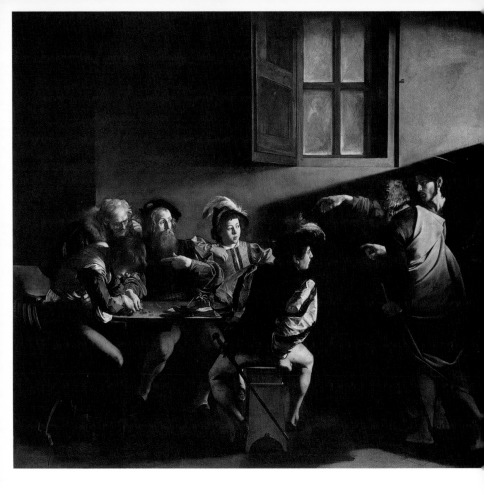

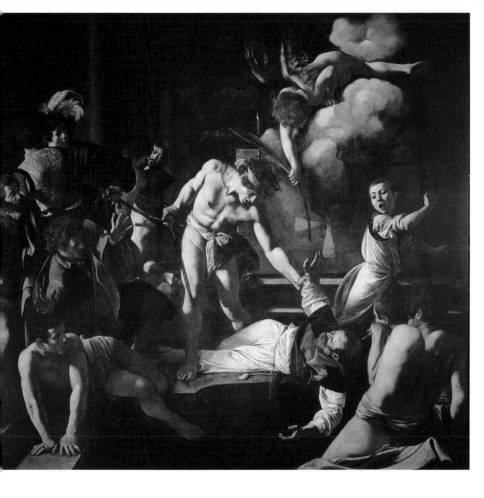

53

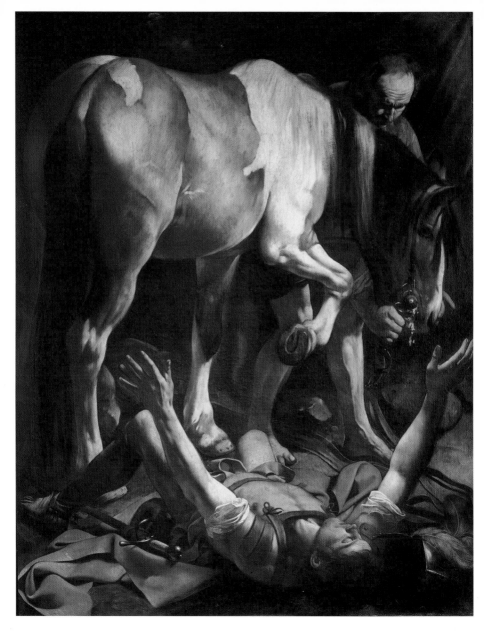

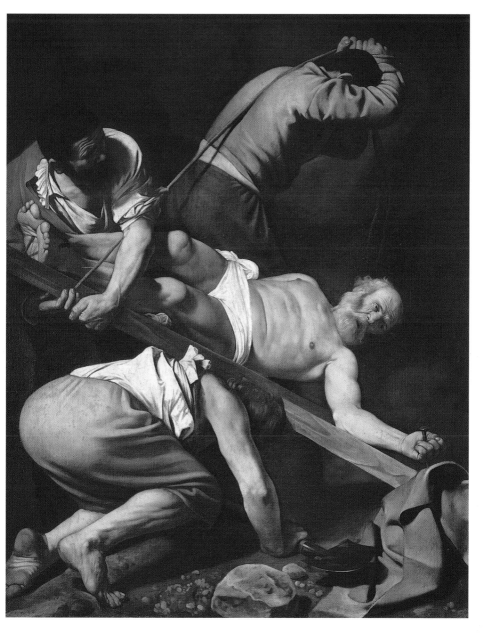

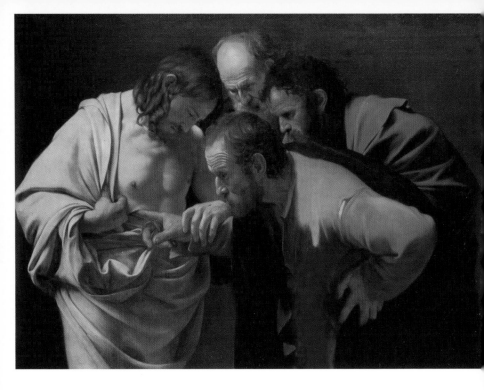

22. *Doubting Thomas*, 1600–01

23. *St. Matthew and the Angel*, 1602

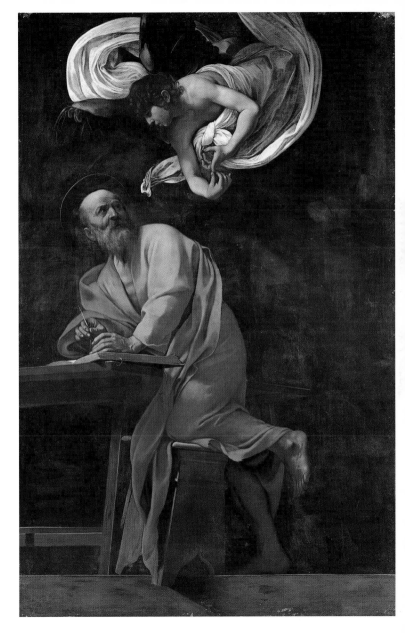

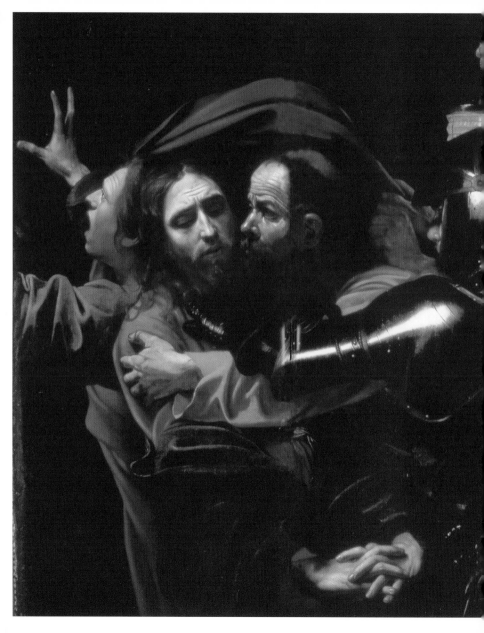

24. *The Taking of Christ,*
1602

Following pages
25. *Amor Victorious,*
1602–03

26. *St. John the Baptist,*
1602

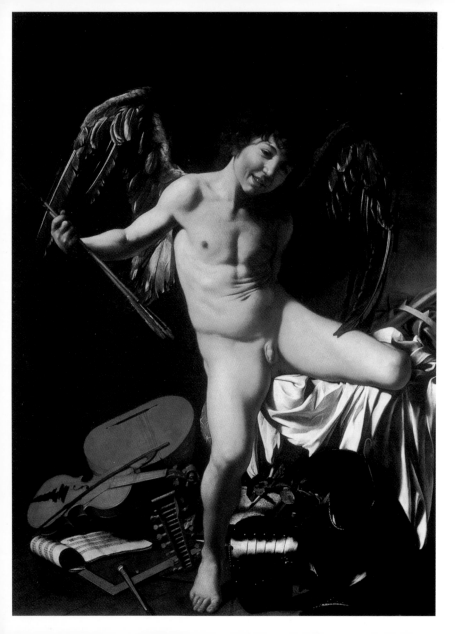

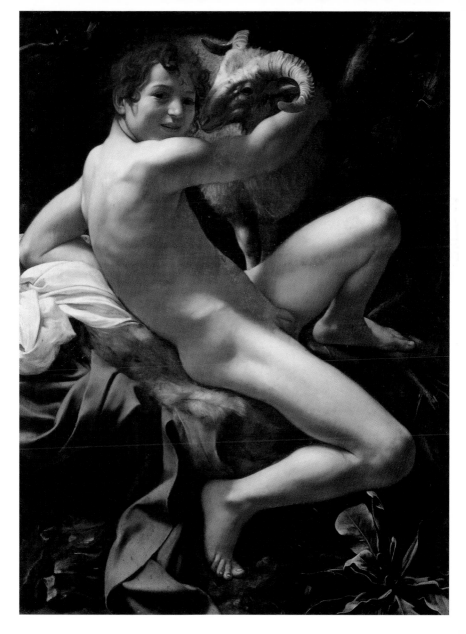

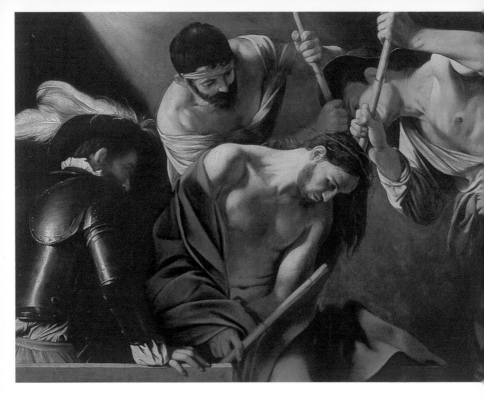

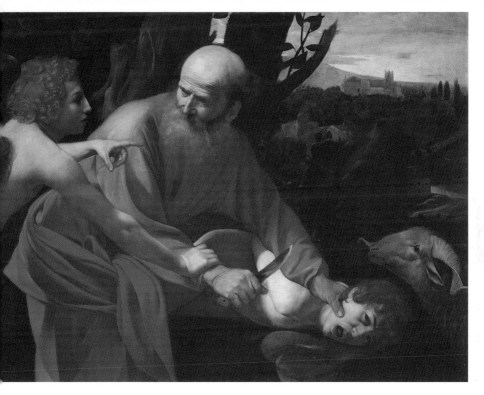

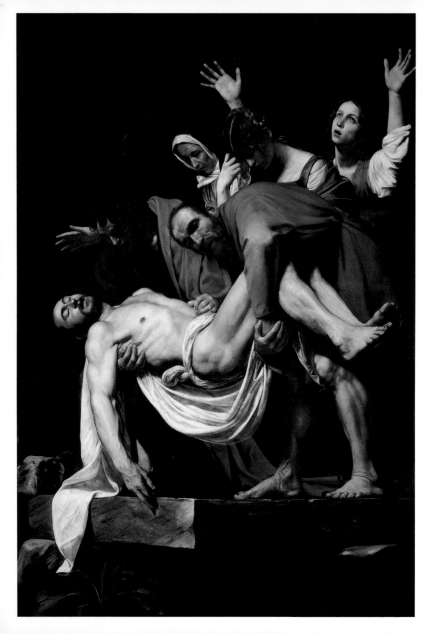

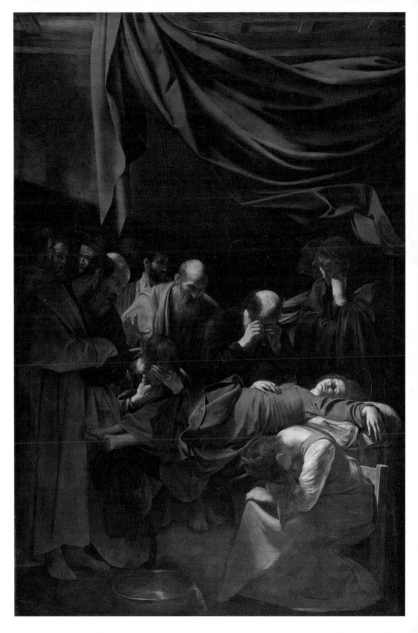

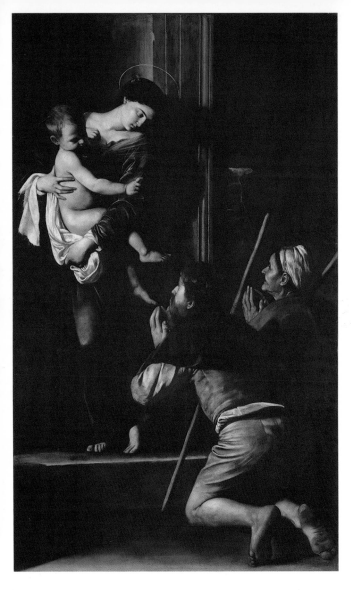

31. *Madonna di Loreto*, 1604–06

32. *Madonna and Child with St. Anne – Madonna dei Palafrenieri*, 1605–06

Following pages
33. *St. Francis Meditating*, 1605

34. *St. Francis in Prayer*, 1605–06

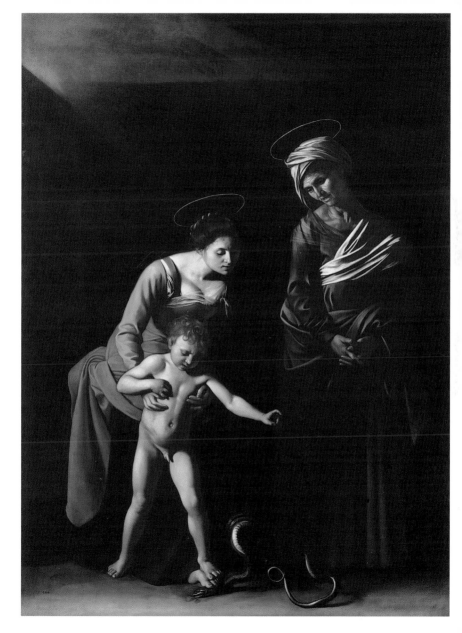

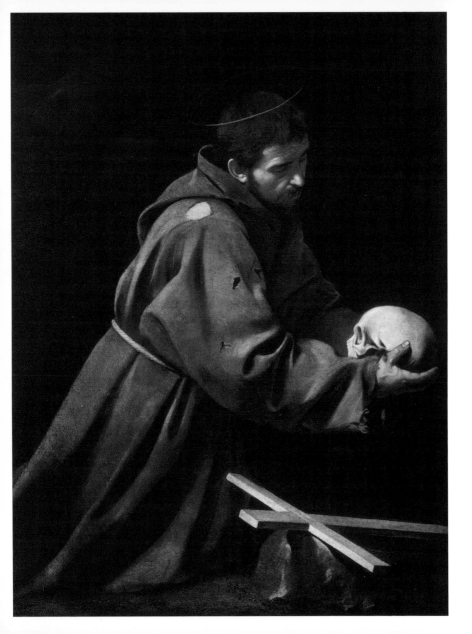

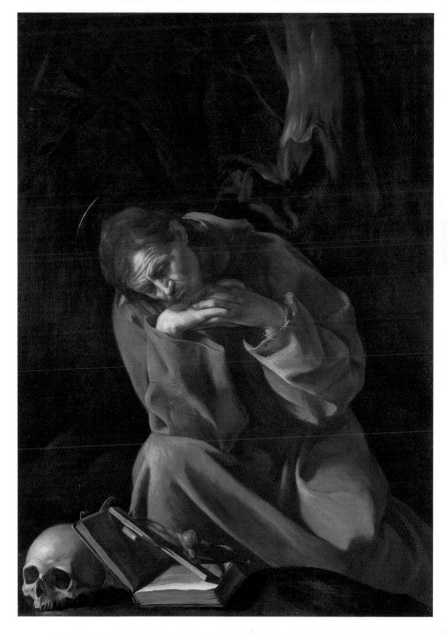

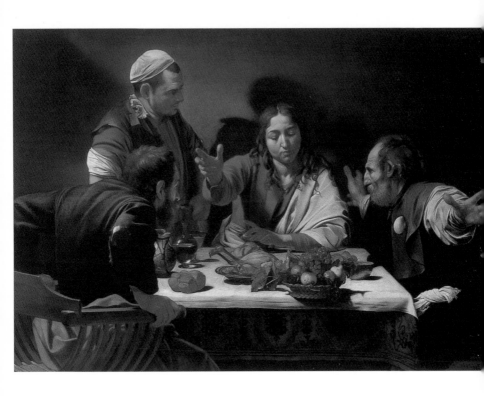

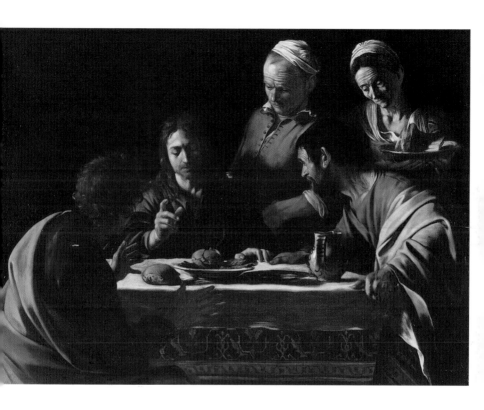

35. *Supper at Emmaus,*
1601

36. *Supper at Emmaus,*
1606

71

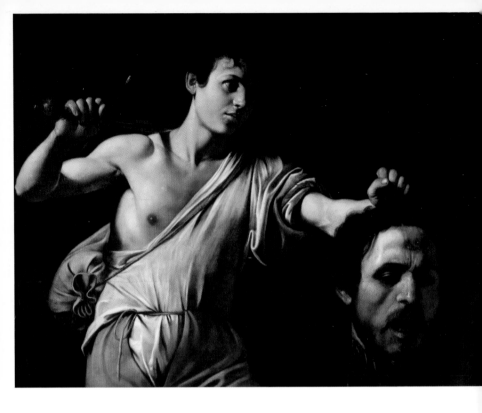

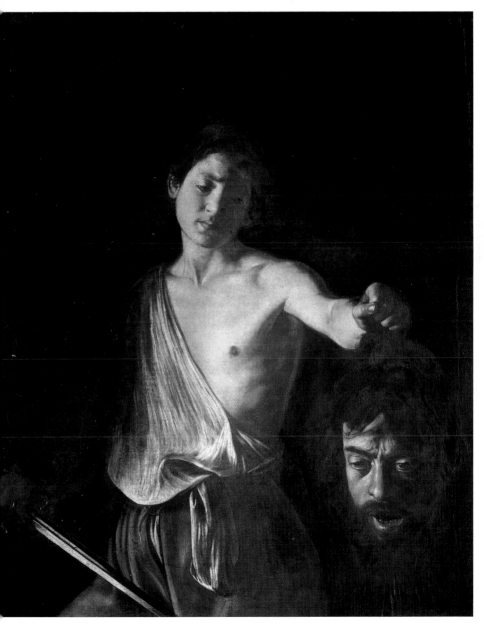

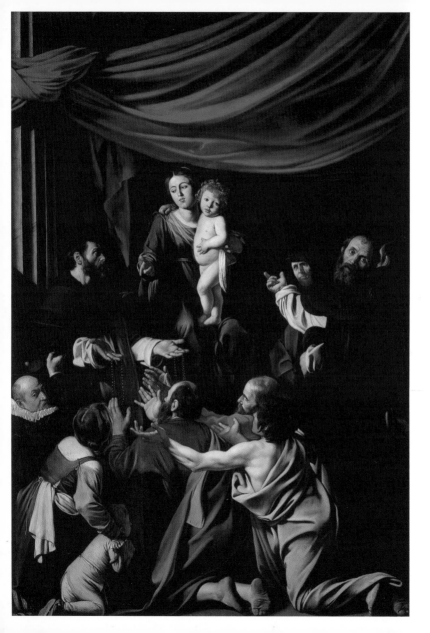

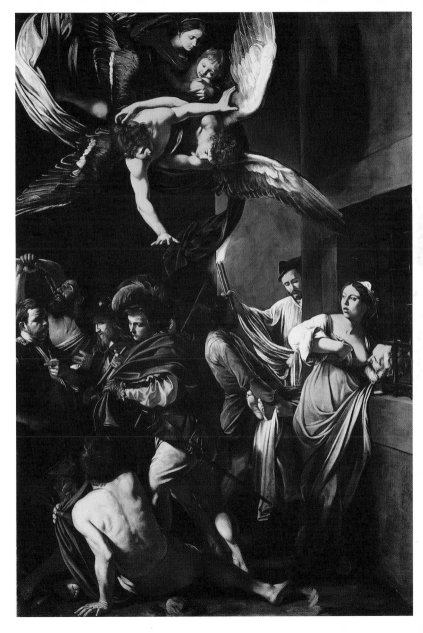

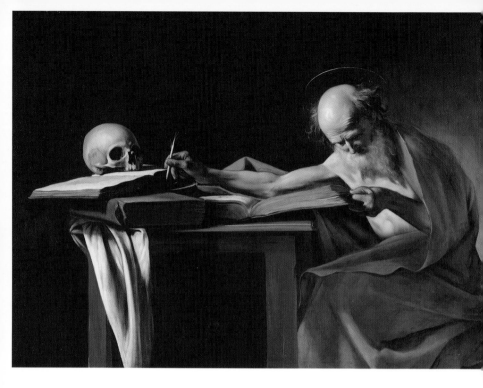

41. *St. Jerome*, 1605–06

42. *The Flagellation*
of Christ, 1607–08

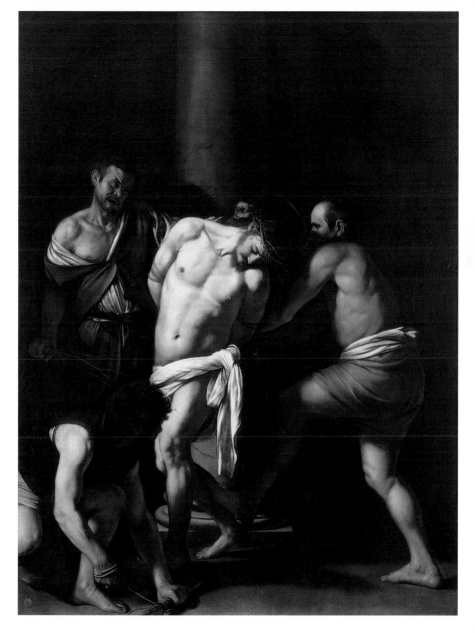

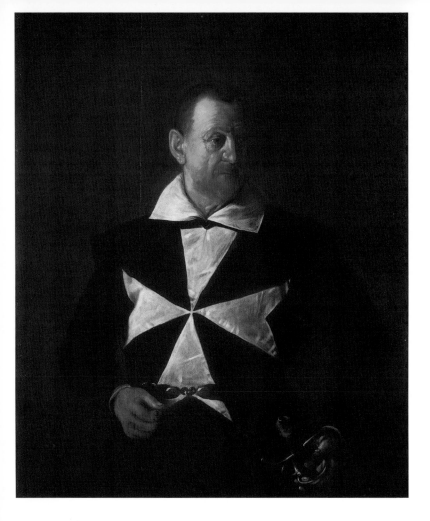

43. *Portrait of Fra' Antonio Martelli,* 1608–09

44. *Portrait of Alof de Wignacourt,* 1608

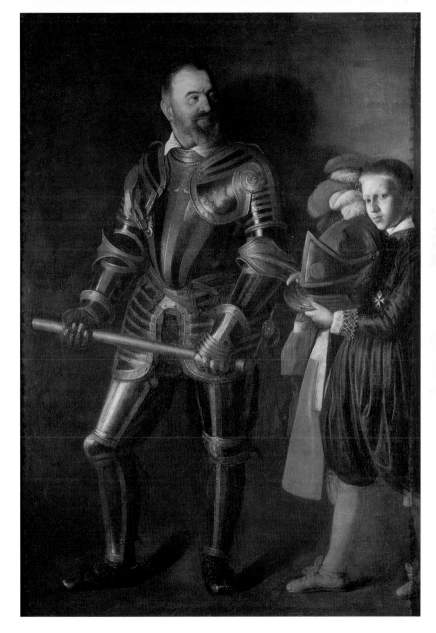

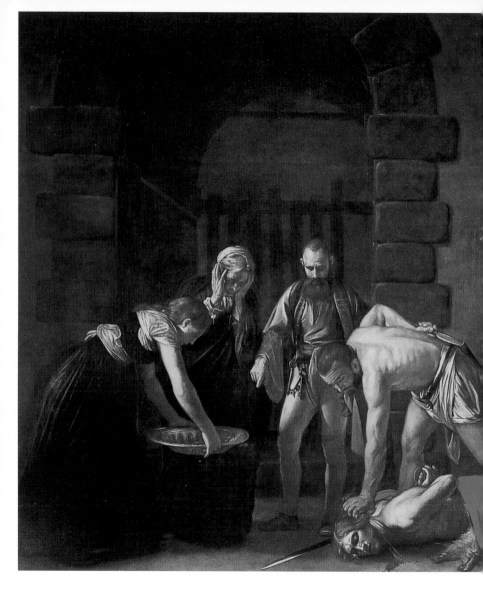

45. *Beheading of St. John the Baptist*, 1608

Following pages
46. *Burial of St. Lucy*,
1608–09

47. *Raising of Lazarus*,
1609

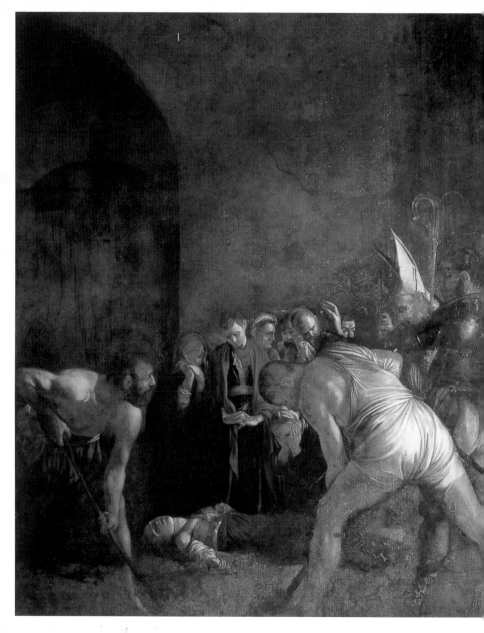

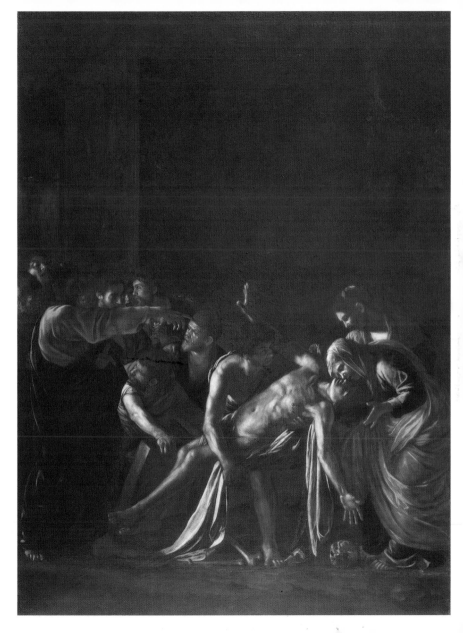

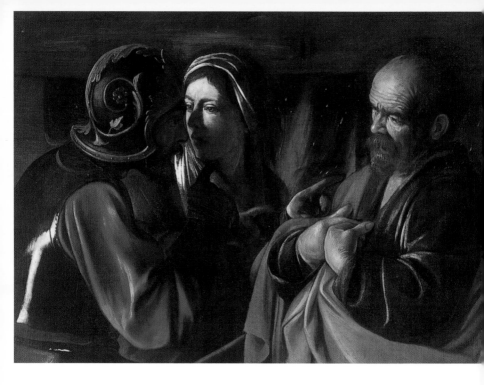

48. *Denial of St. Peter,*
1609–10

49. *The Martyrdom
of St. Ursula,* 1609–10

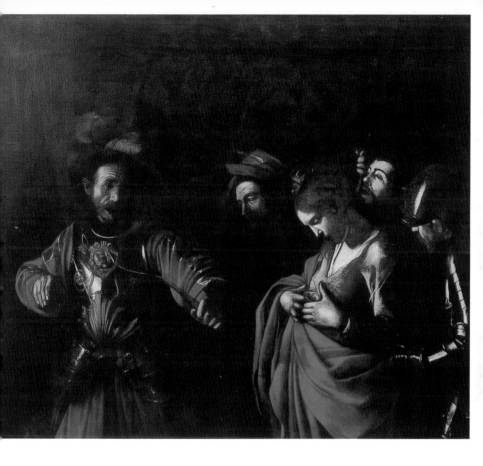

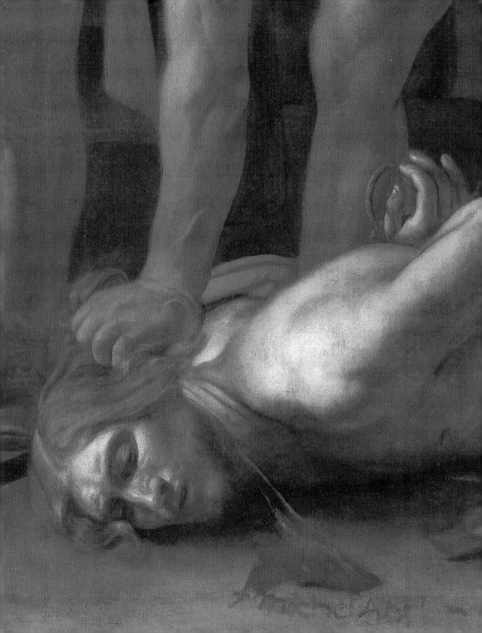

Appendix

Catalogue of the Works

1. *Basket of Fruit*, 1597–98
Oil on canvas, 31 x 47 cm
Pinacoteca Ambrosiana, Milan

2. *Boy with a Basket of Fruit*, 1593–94
Oil on canvas, 70 x 67 cm
Galleria Borghese, Rome

3. *Sick Bacchus*, 1593–94
Oil on canvas, 67 x 53 cm
Galleria Borghese, Rome

4. *The Fortune Teller*, 1593–94
Oil on canvas, 115 x 150 cm
Pinacoteca Capitolina, Rome

5. *The Fortune Teller*, 1596–97
Oil on canvas, 99 x 131 cm
Musée du Louvre, Paris

6. *The Cardsharps*, 1594
Oil on canvas, 99 x 107 cm
Kimbell Art Museum, Fort Worth

7. *St. Francis of Assisi in Ecstasy*, 1594–95
Oil on canvas, 92.5 x 128.4 cm
Wadsworth Atheneum,
The Ella Gallup Sumner and Mary Caitlin Sumner Collection Fund, Hartford

8. *Rest on the Flight into Egypt*, 1595–96
Oil on canvas, 135.5 x 166.5 cm
Galleria Doria Pamphilij, Rome

9. *The Musicians*, 1595
Oil on canvas, 87.9 x 115.9 cm
The Metropolitan Museum of Art, Roger Fund, New York

10. *The Lute Player*, 1595–96
Oil on canvas, 94 x 119 cm
Hermitage, Saint Petersburg

11. *Boy Bitten by a Lizard*, 1595–96
Oil on canvas, 66 x 49.5 cm
The National Gallery, London

12. *Bacchus*, 1596–97
Oil on canvas, 95 x 85 cm
Galleria degli Uffizi, Florence

13. *Penitent Magdalene*, 1594–95
Oil on canvas, 122.5 x 98.5 cm
Galleria Doria Pamphilij, Rome

14. *St. Catherine of Alexandria*, 1597
Oil on canvas, 173 x 133 cm
Museo Thyssen-Bornemisza, Madrid

15. *David and Goliath*, 1597–98
Oil on canvas, 116 x 91 cm
Museo Nacional del Prado, Madrid

16. *Head of the Medusa*, 1598
Oil on convex shield, 60 x 55 cm
Galleria degli Uffizi, Florence

17. *Judith Beheading Holofernes*, 1599
Oil on canvas, 145 x 195 cm
Galleria Nazionale d'Arte Antica, Palazzo Barberini, Rome

18. *The Calling of St. Matthew*, 1599–1600
Oil on canvas, 322 x 340 cm
San Luigi dei Francesi, Contarelli Chapel, Rome

19. *The Martyrdom of St. Matthew*, 1600–01
Oil on canvas, 323 x 343 cm
San Luigi dei Francesi, Contarelli Chapel, Rome

20. *The Conversion of St. Paul*, 1600–01
Oil on canvas, 230 x 175 cm
Santa Maria del Popolo, Cerasi Chapel, Rome

21. *The Crucifixion of St. Peter*, 1600–01
Oil on canvas, 230 x 175 cm
Santa Maria del Popolo, Cerasi Chapel, Rome

22. *Doubting Thomas*, 1600–01
Oil on canvas, 107 x 146 cm
Stiftung Schlösser und Gärten, Potsdam-Sanssouci

23. *St. Matthew and the Angel*, 1602
Oil on canvas, 295 x 195 cm
San Luigi dei Francesi, Contarelli Chapel, Rome

24. *The Taking of Christ*, 1602
Oil on canvas,
133.5 x 169.5 cm
Society of Jesuits of Saint
Ignatius, on loan to the
National Gallery of Ireland,
Dublin

25. *Amor Victorious*, 1602–03
Oil on canvas, 156 x 113 cm
Gemäldegalerie, Staatliche
Museen, Preussischer
Kulturbesitz, Berlino-Dahlem

26. *St. John the Baptist*, 1602
Oil on canvas, 132 x 97 cm
Pinacoteca Capitolina, Rome

27. *The Crowning with Thorns*,
1603
Oil on canvas, 127 x 165 cm
Kunsthistorisches Museum,
Vienna

28. *Sacrifice of Isaac*,
1603–04
Oil on canvas, 104 x 135 cm
Galleria degli Uffizi, Florence

29. *Deposition*, 1602–04
Oil on canvas, 300 x 203 cm
Pinacoteca Vaticana, Vatican
City

30. *Death of the Virgin*, 1604
Oil on canvas, 369 x 245 cm
Musée du Louvre, Paris

31. *Madonna di Loreto*,
1604–06
Oil on canvas, 260 x 150 cm
Sant'Agostino,
Cavalletti Chapel, Rome

32. *Madonna and Child with
St. Anne – Madonna dei
Palafrenieri*, 1605–06
Oil on canvas, 292 x 211 cm
Galleria Borghese, Rome

33. *St. Francis Meditating*,
1605
Oil on canvas, 128 x 97 cm
Church of the Capuchins,
Rome

34. *St. Francis in Prayer*,
1605–06
Oil on canvas, 130 x 90 cm
Pinacoteca del Museo Civico,
Cremona

35. *Supper at Emmaus*, 1601
Oil on canvas, 141 x 196.2 cm
The National Gallery, London

36. *Supper at Emmaus*, 1606
Oil on canvas, 141 x 175 cm
Pinacoteca di Brera, Milan

37. *David and Goliath*, 1607
Oil on panel, 90.5 x 116.5 cm
Kunsthistorisches Museum,
Vienna

38. *David and Goliath*,
1605–06
Oil on canvas, 125 x 100 cm
Galleria Borghese, Rome

39. *Madonna of the Rosary*,
1607
Oil on canvas, 364 x 249 cm
Kunsthistorisches Museum,
Vienna

40. *The Seven Works
of Mercy*, 1607
Oil on canvas, 390 x 260 cm
Pio Monte della Misericordia,
Naples

41. *St. Jerome*, 1605–06
Oil on canvas, 112 x 157 cm
Galleria Borghese, Rome

42. *The Flagellation of Christ*,
1607–08
Oil on canvas, 286 x 213 cm
Museo e Gallerie Nazionali
di Capodimonte, Naples

43. *Portrait of Fra' Antonio
Martelli* 1608–09
Oil on canvas, 118.5 x 95 cm
Palazzo Pitti, Florence

44. *Portrait of Alof
de Wignacourt*, 1608
Oil on canvas, 195 x 134 cm
Musée du Louvre, Paris

45. *Beheading of St. John
the Baptist*, 1608
Oil on canvas, 361 x 520 cm
Oratory of the Knights of St.
John, La Valletta (Malta)

46. *Burial of St. Lucy*,
1608–09
Oil on canvas, 408 x 300 cm
Museo Nazionale di Palazzo
Bellomo, Siracusa

47. *Raising of Lazarus*, 1609
Oil on canvas, 380 x 275 cm
Museo Regionale di Messina,
Messina

48. *Denial of St. Peter*,
1609–10
Oil on canvas, 94 x 125.5 cm
The Metropolitan Museum
of Art, New York

49. *The Martyrdom
of St. Ursula*, 1609–10
Oil on canvas,
140.5 x 170.5 cm
Banca Intesa Collection

	Life of Caravaggio	Historical events
1571	Michelangelo Merisi is born in Milan on 29 September.	Christian fleet defeats the Turks at Lepanto.
1577	His father and one of his brothers die during the plague. The family moves to Caravaggio.	
1584	Caravaggio begins his apprenticeship with the painter Simone Peterzano in Milan.	Death of Carlo Borromeo, Archbishop of Milan.
1588	He finishes his apprenticeship with Peterzano.	The English destroy the Invincible Armada, winning a victory over Spain.
1590	Caravaggio's mother dies.	
1592-1593	He moves to Rome at the age of twenty-one.	Clement VIII's pontificate, which will last until 1605, begins.
1593	He falls ill and is admitted to the Hospital of the Consolation. Shortly afterwards, he enters Cavalier d'Arpino's workshop.	Henry IV of France abjures Calvinism for Catholicism.
1595		Federico Borromeo is elected archbishop of Milan and takes up residence there, but the friction with the Spanish government forces him to return to Rome in 1597.
1595-1596	He takes up residence in the house of his protector Cardinal Francesco Maria Del Monte, Ambassador of the Grand Duke of Tuscany.	
1598		Henry IV issues the Edict of Nantes granting freedom of worship to the Huguenots. Philip II of Spain dies.
1599	The painter obtains his first public commission: the *Stories of St. Matthew* in San Luigi dei Francesi.	

Life of Caravaggio	Historical events
1600 He receives the commission for the two paintings to be hung in the Cerasi Chapel in Santa Maria del Popolo.	Celebration of the Jubilee Year. Giordano Bruno is burnt at the stake in Rome. Henry IV of France marries Maria de' Medici.
1603 Caravaggio and some of his artist friends are tried for having libelled the painter Giovanni Baglione.	James I is the first of the Stuart line to rule in England. The Accademia dei Lincei is founded in Rome.
1604-1605 Caravaggio is arrested for offensive behaviour and for illegally carrying weapons.	
1605 He takes refuge at the house of Marcantonio Doria in Genoa.	After Leo XI's brief pontificate, Pope Paul V is elected.
1605-1606	Shakespeare writes *King Lear* and *Macbeth*.
1606 The *Madonna and Child with St. Anne* is removed from St. Peter's; the *Death of the Virgin* is rejected. The painter kills Ranuccio from Terni in a brawl; he flees to the Colonna estates at Zagarolo and Paliano, then to Naples.	Pope Paul V launches an interdict against the Republic of Venice.
1607-1608 Stay in Malta: Caravaggio executes the monumental *Beheading of St. John the Baptist*, and is made a Knight of Malta. He escapes to Syracuse.	
1609 He is on the run between Messina, Palermo and Naples – where he is attacked and wounded in the face.	Johannes Kepler's *New Astronomy* is published.
1610 After obtaining a pardon from the Pope, Caravaggio dies on 18 July near Porto Ercole, where he had stopped on his way back to Rome.	Henry IV is assassinated; Maria de' Medici becomes regent of France. Carlo Borromeo is canonized.

91

Critical Anthology

A. Pomella

Caravaggio, 2004

Caravaggio is Ulysess's dark pain, the hero "who travelled far and wide (…)/ Many cities did he visit, and many were the nations/ with whose manners and customs he was acquainted; moreover he suffered much by sea/ while trying to save his own life" (*Odyssey*, Book One)

His human condition, estrangement, hard sense of life, the tragedy of a tormented inquisition, make the great Lumbard artist, who lived between the 16th and the 17th centuries, a sort of outrageous reverse of the Homeric hero. His human life was an Odyssey along seas and shores, too; his life was a research of the sense of man, too; he was oppressed by solitude, too. But whereas Ulysses "pursued", Caravaggio "avoided". But who was really Michelangelo Merisi from Caravaggio? A quarrelsome, uneducated, isolated, desperate man. He sought nothing as he had already found everything. And all was inside his very deep genius, inside his painting, where muses and gods became prostitutes and cardsharps, gypsies and drinkers.

C. Strinati

Caravaggio and the Seventeenth Century, in *Caravaggio e il Seicento*, 2006

(…) The aim of this exhibition is to contribute to the awareness in Greece of an area of Italian art that is partly well known and partly almost unknown and forgotten. The towering figure of Caravaggio has come, especially in recent years, to overshadow a host of artists of considerable importance and renown active in Rome in the first half of the seventeenth century. It seems incredible that an experience as fleeting as that of Caravaggio should have had such a deep, lasting and complex influence.

Caravaggio's career was in fact surprisingly short. Born in 1571, he appears to have been anything but a child prodigy. Despite his apprenticeship for four years to Simone Peterzano, a famous Milanese painter of the time, no trace has survived of any artistic work produced by Caravaggio in that period of his youth. Archival records then tell us that Caravaggio arrived in Rome from his native Lombardy in the north of Italy in 1592-93. He was therefore already a young man of over twenty with excellent training, and yet we know nothing of this period either. While illustrious scholars have put forward many hypotheses with respect to a possible early phase, the truth is that the first of Caravaggio's works known to us were probably not produced before 1597-98. In any event, his first authentic masterpiece consists of the three great canvases painted for the Contarelli Chapel in the Church of San Luigi dei Francesi in Rome when he was about thirty years old. Caravaggio's career then becomes clearer as from the year 1600 and it is possible to identify many works by his hand, some of which were produced in Rome (until 1606) and some in Naples, Sicily and Malta. All in all, we are talking about barely ten years of work, during which Caravaggio also went through some very different periods, from the stupendous polished technique of the great Roman works, full of splendour and bold, solemn pictorial substance, to the harsh and painful execution found in certain dark, gloomy and tormented

paintings of the Sicilian period.

Having thus established his greatness, he was followed in his own lifetime by a host of imitators and followers, true or alleged disciples, fierce adversaries and expert copiers. In some cases, their names are mentioned by writers of former times or to be found in archival documents; in others, they prove unidentifiable due to the absence of explicit references, especially in the period after Caravaggio's death, when his works were frequently reproduced, incorporating some technical innovations but always in accordance with his fascinating approach, for at least twenty or thirty years. (…)

V. Sgarbi

Interpretations: from Federico Borromeo to Ferdinando Bologna, in *Caravaggio*, 2006

Despite the fact that the fire lit by him blazed throughout Europe, Caravaggio never received due recognition, even from the earliest, most sensitive, intelligent interpreter of baroque painting, Giovan Pietro Bellori. Little more than fifty years after his death the judgement passed on him is as precise as it is implacable. His originality is recognised: "Caravaggio was without doubt suited to painting, come a time that, nature being made little use of, people depicted practical and mannered figures, and were more satisfied by the sense of vagueness than that of truth. Therefore, removing every little beauty and vanity from colour, he reinvigorated the tints, and gave back to these blood and incarnation, reminding painters of imitation." (…) But Bellori must have been aware of the contagion Caravaggio's painting had inspired. He observes, without hiding his reprobation, in the name of order and harmony, that "many were smitten with his manner, and willingly embraced it, because study and hard work facilitated the tendency to copy nature, following vulgar bodies without beauty. The grandeur of art was thus subjected to Caravaggio, everyone took license, and the depreciation of beautiful things followed. All authority of antiquity was gone, as was Raphael's, where for the comfort of the models, and to portray a head from nature, leaving behind the use of histories, which are the property and duty of painters, they gave themselves over to half-length figures that before then were not much in use. Then began the imitation of vile things, seeking out filth and deformities, as some anxiously did; if these [painters] are to paint some armour, they select the most rusted one; if a vase, they do not do it in its entirety, but foully, and broken. They dress in tights, trousers, and large hats, and thus in imitating bodies they stop and focus all their study on the wrinkles, and the defects of the skin and its surroundings; they form knotty fingers, with members changed by malady. Because of these modes Caravaggio encountered displeasures, as his paintings were taken down from altars." The conclusion, which will guide critics for the following two and a half centuries, is still more severe: "As some herbs produce healthful medications or pernicious poisons, so Caravaggio, even if he were in part suited to it, was nevertheless harmful, and set head-over-heels every ornament, and fine habit of painting. And painters, truly distracted by imitation of nature, had need of someone to set them back on the righteous path; but as one so easily flees one extreme only to run into the other, thus they distanced themselves from the correct manner, and for having followed nature too much they moved utterly far from painting, and remained in error, and in the dark, until Annibale Carracci came

to illuminate their minds and return beauty to imitation."

G. Warwick (edited by)

Caravaggio. Realism, Rebellion, Reception, 2006

Art historians have long argued that Caravaggio often painted his own features in his paintings, above all in the early and late years. This has been posited for early works such as the so-called *Sick Bacchus*, or the *Boy Bitten by a Lizard*. Caravaggio also appears as a bystanders in a string of religious works, from the *Martyrdom of St. Matthew*, to the Borghese Gallery's *David and Goliath*, where he chose to represent himself as the fallen ad decapitated giant Goliath. An inventory of his possessions tells us that he owned mirrors, and surely by this means he painted himself into his work.

Caravaggio only once chose to sign his work; that was in the *Beheading of St. John*, his largest canvas, for the Co-Cathedral of St. John in Valletta. In the painted blood of the Baptist, Caravaggio signed his name as "f. [fra, "brother"] Michelang.o", so proclaiming his knightly status as well as his artistic authorship. Caravaggio painted this work two years after he committed manslaughter and was forced to flee Rome, and after having served twelve months in Malta as a novitiate. The tragic commingling of his signature with the blood of the martyred saint has given rise to discussion of this deed as an expression guilt of hi own violence. An emblem of early modern self-fashioning, like the self-portraits, it seems to speak to us in the artist's own, otherwise elusive, voice. And, like many of the purported self-portraits in which Caravaggio apparently portrayed himself either as the victim of violence, as in *Goliath*, or as an implicated witness, as in the *Martyrdom of St. Matthew*, it memorializes an unstable identity riven with conflict and contradiction.

V. Merlini

The Conversion of Saul, in *Caravaggio in Milan*, edited by V. Merlini and D. Storti, 2008

The *Conversion of Saul*, the only picture of a large size that Caravaggio painted on wood, was commissioned by Tiberio Cerasi in the September of 1600 for his chapel in the Roman church of Santa Maria del Popolo, along with a painting of the crucifixion of St Peter, now lost. (…) The *Conversion of Saul* is a work of extraordinary power. Its proportions, its colours, its plethora of details and its history make it unique. The scene shows us St Paul, blinded by the divine light, lying on the ground where he has fallen from his horse, while two soldiers that were accompanying him react instinctively. Hearing the crash, the younger takes fright, covering his ears and trying to protect himself with his shield. The older, even though he does not understand what is happening, brandishes his weapon, ready to defend himself and the others. The horse, with a glint of terror in its eyes, shies and foams at the mouth, caught up in the confusion caused by the occurrence of something unexpected and incomprehensible. Christ bursts onto the scene, carried in the arms of an angel. The physicality of his figure is such that the branch of the tree bends under the weight of his body, to the point of breaking.

Selected Bibliography

Main sources on the life of Caravaggio

C. van Mander, *Het Leven der Moderne oft dees-tijtsche doorluchtighe Italiaensche Schilders,* Alkmaar; parte II di Het Schilder-Boeck, Haarlem 1603.

G. Baglione, *Le vite de' pittori scultori et architetti. Dal Pontificato di Gregorio XIII del 1572 in fino a' tempi di Papa Urbano VIII nel 1642*, Rome 1642

J. von Sandrart, *Der Teutschen Academie*, Nuremberg 1675

V. Giustiniani, *Lettera sulla pittura al signor Teodoro Amideni*, in *Lettere memorabili dell'ab. Michele Giustiniani*, Rome, 1675, part III, n. 85 in G. Bottari, S. Ticozzi, *Raccolta di lettere sulla pittura, scultura et architettura*, Milan 1822-1825

G. Mancini, *Considerazioni sulla pittura*, Biblioteca marciana, ms. ital. 5571, Rome 1956, 1957

Monographies, essays and catalogues

R. Longhi (edited by), *Antologia caravaggesca rara*, in "Paragone", 1951, nn. 17, 19, 21, 23

B. Berenson, *Caravaggio. his inconguity and his fame,* London 1953

S. Samek Ludovici, *Vita del Caravaggio dalle testimonianze del suo tempo*, Milan 1956

R. Longhi, *Caravaggio*, Rome-Dresden 1968

W. Friedländer, *Caravaggio: Studies*, Princeton–London 1974

M. Cinotti, *Michelangelo Merisi detto il Caravaggio. Tutte le opere*, with an introduction by G.A. Dell'Acqua, Bergamo 1983

M. Gregori (edited by), *The Age of Caravaggio*, catalogue of the exhibition, New York–Naples 1985

L'ultimo Caravaggio e la cultura artistica a Napoli, in Sicilia e Malta, Messina 1985

M. Marini, *Michelangelo Merisi da Caravaggio "pictor praestantissimus"*, Rome 1987

J. Gash, *Caravaggio,* New York 1994

Caravaggio da Malta a Firenze, exhibition catalogue, Milan 1996

H. Langdon, *Caravaggio: a life*, London 1998

F. Caroli (edited by), *Il Cinquecento lombardo; da Leonardo a Caravaggio*, Milan 2000

F. Prose, *Caravaggio, painter of miracles*, London 2007

The Genius of Rome 1592-1623, exhibition catalogue, London 2001

J.T. Spike, *Caravaggio*, London 2001

J.F. Moffitt, *Caravaggio in context: learned naturalism and Renaissance humanism*, Jefferson (NC)–London 2004

V. Sgarbi (edited by), *Caravaggio e l'Europa*, Milan 2005

J.L. Varriano, *Caravaggio, the Art of Realism*, University Park (PA) 2006

K. Sciberras, *Caravaggio: Art, Knighthood, and Malta*, Valletta (Malta) 2006

G. Warwick (edited by), *Caravaggio: realism, rebellion, reception*, Newark 2006

S. Schütze, *Caravaggio. The Complete Work*, Köln–London 2009